JOURNIES OF
FLEDGING STEPS

JOURNIES OF FLEDGING STEPS

AMRITPAL SINGH

PARTRIDGE

A Penguin Random House Company

To order additional copies of this book, contact
Partridge India
000 800 10062 62
www.partridgepublishing.com/india
orders.india@partridgepublishing.com

CONTENTS

MIDNIGHT MOON

At midnight in the
month of June, I stand
beneath the mystic moon,
Embracing, warming
awashing me,
my tired body, my thirsty
soul,
cascading went the vapors
cooling; freezing,
embalming my body,
crystallising my soul.

Moments, hours, days
screeched by,
oblivious was I, blurred;
blurred everything was
except this opiate dewy
vapour,
Which beckoned me, like a
moth fixated on the
candle, my consciousness
just floated me,
over the eons, exhorting me
to be engulfed
by this ethereal vapour.

However lesser
Mortals, me included
were left standing
awash in the mystic moon,
while time passed and I
was left turning to
become Ozymandis
watching haplessly.

CAUSTIC

Caustic, causative,
could you be called
creative,
contrary to what
your puny mind could
conjure up,
 Catalystic, creulous,
 carbolic and much
 cretin were we,
Creation, caring we were
naught,
caresses of humanity
were far away from our
cat like animalistic,
creatures, which came
into caves of our souls,
 Creating niches; corners,
 which could not be
 cohersed to be courted,
 out of our cells, cells
 which coalesced into our
 beings, creating us
Crests of the far away
were captured in the
cameras of our cerebellums,
captured for a life time,
 Can we, catch up
 with what calls
 we make.
Carrying us through
the cardamom the
thick crust outside the
comfort of our parents

and the central ridge,
the coil of life binding,
the central dogma,
 The core of all our
 relations with our
 siblings,
Couldn't you be caught
trying to court sanity
and make this life
and moments more
caring, comforting
can we cancel,
this callous and crusty life.

CARELESSLY SPOKEN WORDS

Carelessly spoken words,
　　　strewn along,
words meant to placate,
　　　words meant to hurt,
words meant to Love,
　　　words meant to arouse,
words meant to cover up lies,
　　　words meant to truth,
words meant for answers,
　　　words meant to appease,
words meant to debase,
　　　words meant to dominate,
words meant to subjugate,
　　　words meant to freedom,
words meant to imprison
　　　words meant to weaken,
words meant to resolve
　　　words meant to riddle,
words meant to solve,
　　　words meant to alleviate,
words meant to torture,
　　　words meant for silence
words meant for verbosity,
　　　words meant to warn,
words meant to wane
　　　words meant to weather,
words meant to forget,
　　　words meant to be etched,
words meant to malign,
　　　words meant to eugolise,
words meant to awe,
　　　words meant to wonder,
words meant to cure,
　　　words meant to disease,

words meant to earn,
 words meant to beg,
words meant to flaunt,
 words meant to shroud,
words meant to secret,
 words meant to humour,
words meant to cry,
 words meant to rasp,
words meant to boom,
 words meant to catch your
 attention,
words meant to fritter away,
 words meant to fume,
words meant to soothe,
 words meant to rouse,
words meant to antagonise,
 words meant to whet
 your appetite,
words meant to hunger.
 words meant to discord,
words meant to harmonies,
 words meant to usher
 oblivion
words meant to create,
 words—words—words,
But no word from you.

SELFISH EMBRACES

Lying in my arms,
 snuggled I thought,
Distant, but distant she was,
 warped and wrapped in
her own designs,
 her own plans,
her own thoughts,
 her own passions,
talking to her monotonously,
 my voice was bouncing off,
I was becoming a bat:
 my hearing being
accentuated picking up only;
 only my voice:
my thoughts, were there
 pouring out, trying to make
a head way:
 events were coming a full circle,
earlier I was like this:
 and she was like me now:
my passions were being
 accentuated, reaching a crescendo
heating me up,
 however my passions
were cooling her; freezing,
 caresses, which kindled her,
were now freezing her,
 causing her to shiver,
Embraces which she craved,
 were now repelling her, stifling her,
she was as if caught in a
 vice like, pythonic grip,
she was becoming distant
 to everything I gave her,

Dreaming, dreaming
 I presume, of far off,
Desires; wants,
 desires of being somewhere;
somewhere else.
 Wanting to move away,
wanting to be alone;
 all alone:
wanting to be different,
 wanting to be wanted,
wanting to be acclaimed,
 wanting to be recognized,
wanting to be wanton:
 wanting; just wanting; desiring
to do what was desired,
 But what was desired
wanting to be away:
 wanting to move apart
be alone:
 Reasons for our moving:
apart were unfathomable;
 to a lay man
a cold detached, selfish,
 person like me:
Asking for this distance
 was not in the right
as everyone has their reasons
 everyone has their cocoon
to go into:
 convoluted, had become,
become the ways of life:
 difficult and incomprehensible
drifting: meandering:
 aimlessly it seemed:
but moving surely and definitively
 to achieve a narrow vision:
vision conceived,
 with own desires, designs in
the fore most,

nothing else was deemed:
right or worth considering,
 Choice was made:
Events; emotions; fury; time
 work at their own pace,
one cannot influence, them
 but also cannot mould them,
like a storm blows out:
 one can only wait and watch:
Time ticked only that much
 more slowly,
I was becoming more cold
 more detached,
more lonely,
 more singular,
more selfish
 And weren't you?

WAITING FOR SOMETHING

We sat there,
 waiting for something
magical to take place
 waiting for chimes to
tinkle,
 waiting for the stars
to light up the sky,
 waiting for the moon
to bathe us only in
 its ethereal, silvery
wash:
 waiting for silence
of the night to
 hear what our heart
beats wanted to say.
 Waiting for the nightingale
to play the musical
 ode to our love,
waiting for the crickets
 to beat on their legs
to herald our visionary,
 platonic love:
waiting for the world
 to recognize that
we were in love:
 waiting for the mundane
to pass in this,
 monumental time in our
lives:
 waiting for the streams
and rivers, play their
 musical fares:
waiting for that
 enlightening ray of

light to brighten
 our knowledge of love:
waiting for that
 moment to tick away,
which we thought had
 stopped when we were
in love,
 waiting, to drown
into the pools of your eyes
 waiting, waiting for your
smile to brighten my life,
 show me light,
waiting, waiting for our
 hearts to melt, forge—
forge into one:
 waiting, waiting we waited
in vain, as time passed:
 passed away.
While we stood
 waiting for all the
magical to happen
 the whale time
came and took
 away, all that came in
its wake.
 Engulfing all that
reared itself; stood up for
 what it deemed
was its.
 Way of life
Time snuffed out what
 stood its ground, In its
way.
 Sand or was it dust
that blew around pervading
 everything filling up
stifling
 up the air.

I was itching with the
 sand dust which
fell in my eyes,
 My ears, were soon
filling with this sand,
 my ear drums
bursting with this building
 crescendos of wind power,
my clothes were itching,
 also filling up with this
sand and dust.
 My hands went to
my eyes, my bony
 fingers encountered sockets,
my skull, where my eyes
 were:
I refused, to believe my eyes,
 I put my hands
to my ears.
 I met with gaps
gaps where my ears were,
 my clothes were
itching: itching
 as my rib cage
was filling,
 filling up with this,
unwanted sand,
 I was only waiting,
waiting for my love.

DEATH CRESCENDO

My eyes were closing,
 so was my brain,
so were my senses,
 but something was opening,
the portals of sleep,
 the portals of road to death,
my faculties of sensibility,
 the faculties of reasoning
were fast diminishing
 everything was going past,
in a blur and I stood watching
 not comprehending anything,
seeing but not believing,
 Not realizing that I was much dead,
Dead to the world,
 Dead to everyone around me,
did I miss anyone,
 did I cry for anyone,
did I want to live again,
 did I want this moment to stop,
did I want time to rewind
 did anyone want this moment to stop,
did anyone want time to rewind,
 can I answer these questions,
for anyone else.
 Can I take the place of anyone else,
can I think for anyone else.
 I was dead but living
reasoning with my sub conscious
 talking to myself,
trying to reason out with myself,
 trying to find answers
to the questions.
 I was asking myself,
all the while,

not realizing,
that I was dying,
 my soul was being
or was it freeing itself,
 from my lifeless, listless body,
I was watching,
 images go by,
images i realized were of my life,
 I was caught up
with this fascinating show of my life,
 Never did I remember,
all what happened,
 only past comes up,
rearing its darker side,
 but one does not see future,
but what is not going to happen,
 how can you see,
is what I was being told,
 my life was slowly ebbing away,
darkness was over powering.
 Light of any kind was being
systematically taken away,
 and my unconscious
was now talking to me,
 revelations came to me, hard and fast
much too fast for me,
 to comprehended all, at the same time,
considering the fact,
 that these talking's,
were beyond comprehension
 did I really have any value for them,
silence is golden
 and I listened,
grasping only some of it,
 the rest left me in awe,
gasping for knowledge,
 of what was being said,
Abruptly everything stopped,
 silence pervaded everything,

it was mind shattering,
 after all the cacophony,
this silence took,
 away the remainder
of my sanity,
 gnawing away at
my senses
 robbing away,
he littlest of my senses,
 dead numb senseless and
lunatic,
 I had become
the unconscious, played revelations,
 that were cold and jarring
warm and cuddly,
 hilarious and rib tickling
the mood swings,
 were fast and true,
try as much as,
 I may,
I could not keep pace with,
 these mood swings,
of my unconscious,
 these revelations,
made my desire
 to finally be,
pronounced dead
 was gaining credence,
and reaching a crescendo,
 I never knew
so many people,
 wanted me dead,
hapless I became,
 my soul fighting,
squeezing its way out,
 left my body,
grunting gasping
 it finally heaved,

a sigh of relief,
 ecstatic to be free,
it moved around,
 found its feet
finally settled to look back,
 at my lifeless body,
no longer shackled,
 it self where,
I do not know,
 but here I was,
much dead,
 desiring for a breath,
the embrace of my loved ones,
 I wanted to live
for another day.

CHOICES ALWAYS

Constantly making choices,
 choices we are making every
day, every hour, every month,
 every year, every moment,
choices are full of questions,
 questions answered by decisions,
by decisions which,
 which shapes our lives:
choices which may be good,
 and some may be bad,
some we lament the whole life,
 whole life later,
choices which, I will ask:
 ask you to make,
If you were to choose someone,
 someone you admire,
would it be me?
 If you were to choose someone,
someone you wanted to confide in
 would it be me?
If you were to choose someone,
 someone you wanted to give vent
give vent to your feeling
 would it be me?
If you were to choose someone,
 someone on whose shoulder you
could cry on
 would it be me?
If you wanted to choose someone,
 someone with whom you would,
share your sorrow with
 would it be me?
I you wanted to choose someone,
 someone with whom you could

laugh with,
 Would it be me?
If you wanted to choose someone,
 someone who could envelope you
in his arms.
 Would it be me?
If you wanted to choose someone,
 someone you could live together with
would it be me?
 If you wanted to choose someone,
someone you could love,
 would it be me?
If you wanted to choose someone,
 someone who was there by your side,
when you woke up, when you
 wanted to turn to help for
would it be me?
 If you wanted to choose someone,
someone whose children you wanted,
 wanted to have,
would it be me?
 If you wanted to choose someone,
someone who would be your friend,
 would it be me?
choices,
 choices which are many,
many and varied
 some made at a whim
some made with deliberation.
 Some made with someone's help,
some made out of love, compassion,
 some made out of spite, revenge
some made to help someone,
 some made to destroy someone,
some made to rust and gather dust,
 But may, may I ask you
to make a choice: without
 without what I have asked:
asked you.

CAN YOU

Can you make up,
for all that is lost,
Can you make up,
for all that is gone,
Can you make up,
for all that went past,
Can you make up,
for all that flowed away,
Can you make up,
for all that you could not say,
Can you make up,
for all that you could not do,
Can you make up,
for all the missed opportunities,
Can you make up,
for the smiles that you wiped away,
Can you make up,
for all the blood that ebbed,
Can you make up,
for all the torture,
Can you make up,
for all the tears you caused,
Can you make up,
for all the broken promises,
Can you make up,
for all the heart that you broke,
Can you make up,
for the child you molested,
Can you make up
for the women you raped,
Can you make up
for the suffering you caused,
Can you make up
for the lives you claimed,
Can you make up

for the unborn you killed,
Can you make up
for the opportunities, you snatched
Can you make up
for all the deaths caused,
Can you make up
for all the land you wasted,
Can you make up
for all that you took from earth,
Can you make up
for all the malice poured out,
Can you make up
for all the hurt caused,

TIMELY EXPERIENCES

Time slowly, ticked away,
 very routinely, very precisely,
very preciously,
 very fast,
caught up as we were,
 with routine, mundane,
ordinary, small,
 petty, frivolous and
time consuming nothings.
 Trying, just trying
to meet dead lines,
 Trying to while away
some time,
 or larger part of the time,
trying to catch up with time,
 trying to beat time,
before we falter, fail,
 and watch the opportunity
miss our out stretched hands.
 Try as we may,
we were so slow,
 that time went past us,
and before we realized,
 much of what we had desired,
much of what we had wanted,
 much of what we wanted to possess,
much of what could be done,
 much of what was done,
had moved away, gone away,
 as the sand could not
hold the water,
 that had been washed ashore,
time came, went,
 came, went,

much like the sea waves,
 much like a desire,
much like a fleeting glance
 of missed opportunity,
much like falling rain,
 much like the falling snow,
time moved with surprising
regularity,
 everything prim and proper,
everything in order,
 a clock work precision,
time saw us lose opportunities,
 which we could grab,
the loss of a good job,
 the loss of someone we loved,
but could not hold on to,
 the loss of a loved one to the
vagaries of death,
 the loss of an opportunity
to make money,
 the loss of a race because we
ran out of breath when
 it was needed,
the loss of life when death
 came on to us,
time came and set up an
 opportunity a situation,
we could not deal with.
 Time came and took
away a day,
 and before one could realize,
Time came and took
 away a year, and
before you could realize
 you had grayed,
time came and
 took away a year,
and you realized that you had
 nothing in hand but emptiness,

as you flashed back,
 memories could only haunt you,
and only tears were your
 companion.
The fading photograph,
 told you that much had gone
and left you alone.
 The wind blew and took along
with it the fallen leaves,
 and sometimes tore the
leaves from the trees,
 much like what time did to you,
were we humans or leaves,
 as we were blown along
 much like them.
Only a few could stand like
 old gnarled trees,
against wind and time.
 But did they achieve something,
 could they tell us something,
we did not know,
 which they knew, or
did they know anything,
 that we did not know or
 experience.

CHALLENGES OF DESIRES

It was an innocuous beginning
 a small challenge:
a turn away from the normal:
 a nurturing of someone:
what would one know:
 it was a yearning
a desire which was
 finally fulfilled:
Finally the dream had:
 come true: the dream
which was unconscious:
 the liking which remained
unkindeld, surely:
 but slowly came alive:
Finally, someone:
 someone arrived on
the scene.
 Who was more helpful,
one who was more considerable,
 One who cared for you,
looked after you,
 One whom you could
open your heart to:
 One who was there to:
to whisper sweet nothings
 One whose advice was to
be heeded to:
 One whose words were magic,
One whose depression was yours,
 One whose joy was yours,
One whose victory was yours,
 One whose heart was yours,
One who could do anything for you,
 One who was these to talk to
endlessly on the phone,

One who was better,
One who was the One you dreamt of,
One you could confide,
One who was there to wipe
your tears,
One who was there to hold you,
One who was there to comfort you,
One for whom you could dress up for,
One who dresses you up in his love,
One who was there when the other was not there,
One who could be relied upon,
Finally you could make
a choice.
Finally you chose the
other One
It was your decision,
it was your desire,
it was your fulfillment:
It was your choice,
and the first one:
first one was left,
left to look on:
Not in despair,
Not in sorrow,
But in defeat,
left to be the second helping,
left to be a left over,
left to be anonymous,
left to rust and rot,
left, just hanging,
hanging on to his past,
for now he had become:
the other man.

THE SUN BEAT DOWN

The sun beat down,
 mercilessly:
knowing no friends,
 warming, scorching,
burning everything:
 every being:
The wind blew:
 blowing around:
blowing away everything
 raising the dust
driving the sand
 all around: all over.
The desert began,
 began to play,
play with the
 visions:
making the desire:
 desire the quench:
quench this: this
 thirst: thirst for
knowledge: of adventure,
 to know, to explore
the ultimate of
 everything.
But; but at this:
 this moment
the thirst for water
 was over powering:
to dab the thick,
 thick tongue,
with a few sweets
 fresh drops of water
to wet the parched:
 cracked: swollen

lips was all:
 all consuming:
The clear blue:
 blue Oasis
looked close; but,
 but yet it was
so far away:
 Ever alluding,
But then did: did
 I really quench,
quench any thirst:
No; No I couldn't
 even quench:
quench the thirst
of myself:

BABBLER

As more we talk,
 more we talk,
the more we expose,
 expose ourselves:
Sitting where we are:
 we tend to be
decadent: tend to
 get sores; shall I say bed sores:
our brain also
 tends to get bed sores:
as we sit: sit
 in the same old
groove: doesn't,
 doesn't mean sitting
As also not opening,
opening your thoughts
 minds: to new:
new ideas also
 makes, makes us
sit: sit in the
 same place: same
position: same groove:
 and we babble: babble
and continue talking
 thinking that, that
we speak:
 are pearls of wisdom
just about as a
 gospel of truth:
Not realizing: realizing
 that somebody else:
who is open in
 thoughts: all this:
this humdrum
 is jarring: and tends

to make one revolt:
 but the meek, stupid
and cowed down that we are
 can just listen but
in: in abject silence:
 mesmerized: mesmerized as
if by a magician
 doing: doing what:
what is told: the
 monologue
continues: continues
 a rote: rote mechanical:
jarring: jarring
 peaking to a crescendo:
a babble:

SOMETHING THAT NIGHT

One could make it
 out; that
there was something
 that night
in the air:
 which made me
feel happy,
 light hearted:
The cool breeze
 freshened me,
made me feel
 light and springy.
The stars twinkled,
 so bright and gay
distant,
 far away from
this mundane
 world, this
stuffy cramped
 environment
moon was not
 to be seen.
Hidden some where
 in the vast, expanse of this
 universe, the
limitless sky:
 Why?
Don't we know
 when and how
these things are
 controlled:
who is behind
 these absurdities?
We call these
 goings on

absurdities
 cause we don't
know about them,
 haven't learnt
about them.
 So the ignorance,
Ignorance of this
 knowledge
is condemned.

SO FAR AWAY

Living as we were,
 so far away,
but not so far
 ever so near.
All this humbug of:
 of being close: close to heart
in your thoughts:
 all so mushy and romantic,
but never so real because reality
 was far fetched from imagination:
from a dream.
 Reality was and is a knee jerker,
a rude shock something which made,
 you throw up,
something which was repulsive:
 something ugly:
It has its moments of glory:
 Its moments in the sunlight,
Its moments of crowning victory:
 But always and mostly,
it took you into depths:
 depths of despair
depths of despondency:
 something one resigned to
unable to control:
 unable to ride:
unable to fathom,
 something which over ran
over ran you:
 like a tidal wave:
like a steam roller,
 which, which left
you all plastered,
 plastered all over

the road: all over the place:
 to be scraped off and put into,
into small: small
 plastic bags
to be disposed off:
 It was something which
did not appease you:
 something which was offensive
something which made you throw up:
 something which made your stomach churn.
Something which made you realize
that falling into dream:
 falling into, into depths of imagination
 was all too good
and reassuringly
 smooth and soothing.

FLOWERS OF DESIRE

Were I a flower what would I do,
and I shudder to think
what would,
would be happening
to me.
> I would be:
> growing to come out of my seed
> to break the crust of the earth
> to experience the heady
> and heavenly
> feel of the
> first rays of sunlight:
I would be growing to
break free from the
confines of the
green leaves
encompassing me.
> I would be growing
> to spread splashes
> splashes of bright and varied hues,
> to make the garden of life
> more colorful and brighter.
I would be growing to spread
spread fragrance in this
foul filled air.
> I would be growing to be
> be presented to someone,
> who was loved
> as a token of love.
I would be growing to be
Be made into a bouquet to be
presented to a; fat, ugly
and preposterous lady,

I would be growing to be
Be preserved in between fading
Fading yellow pages of a book,
a soveniour for someone,
who could not be ours.
I would be growing to be
Be made into a garland to
To bethrow
two people in a
A bond of marriage or
Or adorn,
the neck of someone honoured
at a drop of a hat.
I would be growing to be made
into a gajra to adorn some
lady's hair, to please
a loved one or to attract
attract a customer to sell her body
and make some money.
I would be growing to adorn the frame
frame of someone long gone
and remembered once a while as a sham.
I would be growing to be torn
torn petal by petal as an
offering to someone to someone
of great eminence,
or an unknown soldier long gone,
or to a deity to please that deity:
and left to wither and
to be tread by an old fart,
whose path I cover.
But does anyone wonder,
what I want when I grow and.
This meaningless existence,
I wish I could I stop this,
But then like all other things that go on
I also grow.

CIRCLES CIRCULAR PATH

All of a sudden,
it seems that:
I have run out of ideas to pen.
Do you think that by
going through this process,
I will be able to get back,
my old poetic touch:
my touch with fantasy,
then I am and you are wrong,
this decaying crumbling
edifice can do can do nothing to
help me.

 I will keep going further and
 further away from what I had.
 Nothing seems to move
 and nothing seems to spur me on.
 Life has become decadent
 with nothing happening,
 it seems that life has now
 become a great big
 zero.

But then even zeros
have a circle,
starting from one point
and finishes on the same point.
To travel from this start
to the finish point.
Which are nothing but
one only,
I takes infinite time
to do so: and then
treading on the same line
makes one careful of the path.

Makes one look down and
walk a bit more slowly,
a little more steady,
a bit more dreary.
As the fear of stepping out
of this path,
may take him into uncharted
territory, may be into darkness
as only that that circular
path is lightened.
All of a sudden, all doors,
all paths are closed and
I am left standing on the
circular path.
I am scared of stepping out
what is there, I don't know
is there a never ending cliff:
or are fires of hell raging;
or is there darkness,
or is there loneliness.
But then isn't there loneliness
on this circular path.
But wont there be an unending cliff.
Wont there be fires of hell raging
ahead of me.

Because I don't know what
will come ahead, as had I known,
what lies ahead on this
circular path, I would become
a futuristic and would
remain stagnant, and would have
made this path a video game
and could go over:—around:—under:-
all hurdles that come.
But for how long do I make
this game move in slow motion
or do I make it go at normal speed
or at fast forward.

Let me not be futuristic
or nostradamic in my vision,
as it is better that I do what
I was doing earlier; moving on the
circular path.

 As life goes on; and I move
 so ever slowly on this zero;
 life tends to become
 decadent; putrid; and stale.
 Where have all the air cleaning
 air conditioners gone, have all
 the exhaust fans stopped.
 The air has become still and stale
 and it has become stuffy.
 With all these people breathing
 the same air that I breathe,
 and with all the breathing
 down my neck, it has become
 clammy; and sickening; and
 I find myself short of breath
 day in day out.
Isn't there any fresh air left
in this place.
Can somebody help me, by
bringing in some fresh air
can someone open the windows.
Can someone. put on the exhausts
and the air cleaners and the
air conditioners.
Its time someone did it.

 But the fools that we are,
 we are so busy in moving; moving
 on this zero, on this circular
 path: that we do not have
 time to do anything; anything
 out of the normal.
 But just move on this zero,
 over and over again, till we get

salvation; **moksha;**
or is there **moksha.**
Because I do not remember
nor do many remember their
previous lives.
I fear death and would do like
to be eternally alive:
Is that possible: No;
Then should I move on;
on this zero:
Yes I hear only yes,
but no, No.
How narrow sighted
all you are; because.
You are moving along,
So you want me also to
move along with you
On this Circular Path.
On this Zero.

WEBS OF PASSING TIMES

What were to happen,
If you were to die, would
it matter to you, would anyone
come to your dead body and
genuinely miss you, would
anyone come to your dead
body and shed tears of real
Sorrow.

> Who would miss you in their
> times of joy;
> Who would wish you were
> there when your presence
> was needed in times of need.
> Who would desire your being
> there when sex over powered them.
> Who would cry for your help
> in times of calamities.
> No one,
> No one will come
> to do all this.

As time carries on ticking
and passing away; as lives keep
living on, and are caught up
with mundane regularities
which become important and then
start to assume larger
than life proportions.

> With passing hours, the grass
> slowly but surely started its journey
> on its way out of the top soil,
> and had yearning to be touched
> by sunlight; to grow:—expand:-
> breathe; spread slowly but surely
> over your grave; and all of a

sudden, you lying beneath this
unending and growing maze
of roots, were being suffocated
the breath being
pulled out of your bones,
the breath, being
pulled out of your soul,
slowly killing you Ultimately.
The photograph on
on the mantelpiece was
showing sights of small little
traces of the movements
of spiders and ants.

The spidery, spiral sticky,
web was sewing you up,
in ever so widening circles
making your skin crawl
and you wanted to scream
and shriek
and scare away.
These unwanted, omnipresent
crawly beings.
Who would have otherwise
been squished by you if
you wanted
or you did not desire.
Flowers draped around the
elaborate frame,
had since lost their smell
and you had forgotten their colours
and had forgotten their lingering
fragrance.

Flowers which you so lovingly
and passionately and with
labour that you
planted

Were now draped in a
ritual all over your frame,
and were so carelessly
strewn over you grave,
Then I think wouldn't you also
do the same
and that's what you did
as long as you were alive
and living
and we lived by
Out of sight is out of mind.

BECOMINGS

As the water poured and fell:
fell on the rooftop
and kept the same
humdrum on for a time;
time that seemed to be
an eternity:
I was being put off:
put off from being a romantic

 And now instead of loving:
 loving the rain; the rain drops
 I started hating the
 monotonous sounds of the
 loud and ear shattering
 water cascading
 down the mountain side:
 rising to a crescendo and
 leaving my senses numb:
 numb with pain.

I was beginning to hate
all that nature was:
all what it stood for:
all that nature was:
throwing up at me:
I was beginning to throw up:
I was beginning to hate:
hate the all enveloping fog:
which was choking me, suffocating
me:

 It was no longer a treat:
 treat to watch the hills:
 in their green and coloured glory
 to see some wispy clouds:
 some cottony clouds:
 belching out rain:
 rain at sporadic intervals.

I was beginning to hate,
hate the creations of nature:
the insects the spiders, the flies:
the bugs the bees:
with their beautiful bodies:
they were now ugly: with stings;
with probosis: they went about pricking
poking every one:

>All of a sudden, the sun was
>not so yellow and not so bright: the sky,
>sky was not so blue.
>The rainbow was not so colourful:
>the snow was black and brown.
>And not so white and pure
>as it was to be:
>the rain was acidic; yellow and
>filled with dirt:
>was polluted and not so pure.

But, then there were
others; others who; who were
still romantic; romantic
at heart; and who still saw,
saw the wonder of nature;
I ceased to be romantic;
romantic of the heart; but
I was, was romantic of the mind.

>Pleasures were no longer needed;
>sights were no longer seen;
>seen and savored.
>Feelings were no longer touched;-
>smells were no longer to be smelt
>and remembered
>Tastes were no longer, lingering
>on the tongue;—and which;
>which were no longer savoured.

As I was becoming blind.
As I was becoming Deaf.
As I was becoming Dumb.
As I was becoming Paraplegic.
As I was becoming Dead.

READINESS FOR THE PAST

As time was passing,
passing away and it:
 it was time to go: go
back to the security and
 serenity of my home;
the four walls: my:
 my counter pane covered bed:
there was still: still time to
 muse over what had
transpired today: yesterday and
 the day before; and years
and months gone by:
 But was it necessary:
necessary like the necessary evil:
 when I had to think of
the warmth and closeness:
 closeness of my quilt: my
thoughts. The hot cup of coffee
 and the ensuing dreams.
Hopes and desires of the coming
 days ahead: which—
which lay ahead of me:
 a distant away, but
many days ahead, many
 miles ahead: The distance
I had to cover: cover from
 my home to the office and
back and many miles to
 cover in unknown journeys:
Journeys to different places:
 For pleasure; as a part of my
Duty
 Duty to my loved ones:
Duty to my job:
 where do these journeys

take me I wonder:
 I wonder as my feet start
Dragging;
 as my eyes become weary:
As my thoughts seize to come
 as my mind becomes cloudy
as sleep is becoming over—
 powering
as my bed beckons me:
 as I go to sleep.
Getting ready for another day.

BEAUTIFUL

Beautiful,
 you are:
Beautiful as the rose
 Beautiful you are
because you think,
 you are:
Beautiful you are
 because you look
Beautiful:
 Beautiful you are
because beautiful,
 you talk:
Beautiful you are:
 because beautiful,
you have to be:
 Beautiful you are:
because you make
 others happy.
Beautiful you are
 because people
make you happy.
 Beautiful you are
because I see you
 Beautiful:
Beautiful you are
 because you see me
Beautiful:
 Beautiful you are
beauty is seen by you.
 Beautiful you are
because understanding you are
 Beautiful you are
because warmth is in your heart.
 Beautiful you are:
because above all
 I like you.

WISHING WHY

Why: Why
do we do what,
what we do:
Doing unimaginable;
unimaginable deeds.
Actions unanswered.
Acting: acting on whims,
whims and fancies:
Never: never for a moment:
realizing: thinking what
what we are doing:
falling in love:
despising someone with:
all our mights:
transacting deals
speaking as usual:
walking for the fun of it
Running to keep fit:
Running to catch up:
Running from someone:
Running into someone:
Running from every one:
Running from death.
It is always on the move
either at a hectic pace, or
flowing languidly: peaceful:
far from the maddening: boisterous
vociferous world:
God: God ordained: ordained
this peace: this tranquility.
I have changed: changed to;
compete for: for my existence
for my food:
for my water:
for my house:

for my breath:
for my money:
for my love:
having, having
found you: and your love:
this world; in your presence: is
is as what God ordained
for how long can we be: be this way
for we both will have to join:
join the race: the maddening world:
This: this shell helps: helps us to
breathe: to relax:
How I wish:
wish: wish that we:
we could always: always be
together.

SOLACE

When does this end:
this drudge:
But why do we
curse and degrade
this life.
Cause we do not
find every thing in:
in accordance with,
with our wishes.
Our likes our dislikes:
For we have not found:
found everything,
so nice and rosy
we always thought,
thought that life shall,
shall be a bed of a
cushioned mattress
Alas it is not so:
It is Gods decree
that everything happens:
everyone lives,
everyone dies:
yet we never mortals
nonentities flaunt
everything.
Challenging: Fighting,
wrestling with Gods
decree:
Yet we have not learnt:
learnt from other mistakes,
mistakes others: have
committed and failed:
failed to get even their
fingernails to the

ladders of success:
Other who have found
Found solace in the
decree of God:
have succeeded
climbing: climbing
so very slowly on the
ladders of success.
The solace: solace may be
patience: penance: worship
affection: love:
of all the solace love: love
stands up: over and
over
all others:
it's the highest, highest
pinnacle of solace.
One feels so very contended
so very peaceful:
so very happy:
so very oblivions:
oblivions of mean
self centered mortals:
around then:
Finding a new life:
a new direction:
a new way to tread:
a new out look:
love binds: holds and
takes along two people,
along this path of life:
giving them strength
giving them light:
Guiding them all along:
till the very end:
till the very last breath:
till the very last beat of the heart:
till the very last flutter of

eyelids:
till the very last feel of the
touch of a loved one:
till the very last look of the
Loved one.

COLD HANDS

The dawn brings:
brings along colours
light cheerfulness zest
and above all a new
day, a new hour: a new minute—a new:
a new life.
The splashes of colours,
the songs of birds
reminds me of days past:
days of brightness,
days filled with joy
days filled with love,
days filled with fragrance:
Days when time was
spent: spent talking,
talking of everything,
everything and nothing
holding: holding hands
feeling love flow through
every fibre, every pulse
felt at the fingertips:
Days spent: spent doing
nothing: just sitting and
lying down close to each
each other:
holding each other
feeling love, oneness.
Surrounding us:
Enveloping us
the coolness: The slight
breeze blowing
making a small chill go
go through me:
make me shudder a bit

making me hold: hold
my cup of tea,
tea more firmer
try to warm,
warm my cold hands.

WINDOWS OF WIND

Looking out:
out of the window:
watching the breeze run by.
Playing with old friends,
trees, flower, bushes,
grass
lifeless forms—or
do they have life.
I muse over,
what
has happened
how time has passed
by: so alike wind:
which rushes past my
window.
I can do nothing but
watch it run by:
watch it frolic with
its friends.
While I sit here
all cooped up: fearing,
fearing not to move
out of my shell:
Images flash past:
conjuring up memories
of the past.
Like: like a comforting
lullabye: bringing:
bringing back
memories:
all soulful and joyful:
making:
making one stare vacantly:
vacantly with no thought clouding:
clouding my thoughts.

At times,
musing over sweet lined
Memories, at times
munching over
bitter lined one memories.
Bringing,
bringing me back to my:
my window pane.

STATIC—BY CHOICE OR DESIGN

Sitting: Sitting
here listening:
listening to: to
a warbler,
what does one do:
being subject to
something: something
which does: does not
interest me: or anyone
else:
My minds drifts: drifts
to sleep: wanton and
unconfined: it helps:
helps me to shut off:
But at times: its alive
and kicking.
Making me wonder
Wonder as to what
am: I doing with
my life—wasting it
here, when I could be
Home, with the people,
I love:
who are dear,
dear to me.
Doing what I wish and will.
Unlike: unlike what I am
subjected to do: much to my
disliking: This is what
I had opted for on: on my
own accord.
Nothing changes of own accord.
The river flows:
life moves on.
The Earth rotates.

The Sun rises and sets
The rains come and go.
It snows:
But we remain static:
If you think:
think you got me: you;
you haven't
our minds are:
Also static.

BUMPKIN

There he stood,
stood like a master,
surveying his conquests,
A fallacy,
A short lived dream
which he knew would:
would end.
But like all:
all aviracious; pompous
and selfish monarchs,
who loved sycophancy.
He wanted:
wanted this moment
to last
wanting to do what:
what all he could conjure
up in his:
his bean sized brain:
covering himself:
himself with glory
was all that he wanted.
But sycophants,
who wanted more:
more than the pompons
bumpkin.
Manipulative, scheming
as they were.
This bumpkin: was:
was an ideal foil.
For: for
They knew and knew
always that,
that if heads will,
will roll: Bumpkin's
is the one that will:

will be guillotined
The Bumpkin,
pompons;
avaricious; bean brained
monarch, knew,
knew not this.

CHANGES

Farce; farce
is all, that this
world is, and
we love being
involved: involved
in it,
More like a love:
love affair: which,
which hits you once
and for always
with no warning:
Nothing changes: but
we do not: do not
accept any changes
as change is not: not
acceptable to us.
Living; living in fool's
paradise in our forte: and
and we don't think it
otherwise:
Changes are for other: but,
but not for us: Its always:
always the same.
Nothing in hand:
but every: everything
Everything to do.

USURPER

With a mean look
and hungry eyes,
malice in heart,
scheming mind:
worming his way into:
into your work.
Stepping on stones:
made of human heads,
steam rolling their jobs
and going ahead:
Not knowing much;
But posing as the ultimate scholar.
Does he know it all.
Does he know what he is doing:
Does he knew what goes on in other's mind,
What does he know of the emotions;
The pain:
sorrow;
dejectedness:
that runs in other minds:
Sometime:
sometime later;
when will it happen
that fate catches up and
teaches him;
what he did.

BIRDS OF PREY

Birds of prey:
prey that we are:
waiting; hovering
on the side—lines; above:
above: some one:
some one small, weak:
weak or meek,
submissive or incapacitated:
waiting, pouncing,
pouncing on the small:
making them cover,
cover in their hide—holes:
Strong talons: tearing,
tearing in to their weak
soft spots; Glorifying
their victory: victory
over lesser mortals; making,
making them cringe.
Cringe with fear—always
and every time; But
shallow is their victory
As another vanquisher
stoops over them.

GAMES

Everybody is on his own;
playing his own game.
Over the same chess board:
Pushing, jousting, punching.
Clawing their way out:
Making it more of a hotch—potch.
The actual players finding it:
It very difficult to actually
plan; plan their moves.
These pushy persons don't;
don't get anyway; anywhere
nor do they let any one
work; plan out their way:
Its more of a ball game:
and every one is on his own
ball game:
So there one a lot of balls
only BALLS.

MAY BE

May be:
May be I love you,
or do I ADORE you,
I am confused.
But one thing I know,
you: you are my life:
The breath is more wanted,
the heart beat more strong.
The desire to live stronger,
The air is more cooler.
The day more brighter,
The nights more warmer.
Bringing: bringing me
closer to you,
Cause I dream of you,
You the whole night long,
The day more bright as,
As I think of you the whole
day long,
The air more cooler,
Cooler as it bring a;
A whiff of you always,
You are far; far away,
but why is that;
that you are close to me:
close to my heart.
All this tells, tells me
that I love you,
Thanks; thanks once again,
for telling me what;
what love is;
what life is,
I wish you came;
came into my life

much earlier.
But the wait;
wait to find true love,
is the wait,
everyone waits for.
Well, what more do I say.
Only that; that
I love you.

REMEMBRANCES

Touched,
I am by:
by remembrances
thoughts,
and memories.
Which remind:
remind me of you,
The small, small
loving gestures,
eyes meeting,
telling us so many
unsaid words,
stories.
The hands touching
telling us something,
Something more.
The lips meeting,
telling us
we love.
Love each other,
touches, telling,
telling us of hidden;
hidden passions,
so over powering
so sweet,
so tender,
bringing us together,
thought, thoughts,
of the future,
a picture, so very
vivid and etched
in various hues
in our minds,
telling us
of a life;

life which we are
going to,
live,
Memories,
of moments past,
lingering, caressing
us;
stirring up emotions
sentiments,
precious treasures,
for the rest of our
lives.
The first meeting,
the holding of hands,
Looking into each
other eyes.
Saying the magical,
magical words,
I love you.
The kiss, which was:
was short,
but seemed to
stretch for an
eternity.
The touch stirring
up passions.
The knowledge:
knowledge of
having found, true:
true love.
All a fairy tale:
come true.
To fill our hearts,
Lives,
souls; for the rest
of our lives,
never, never for
a moment did,
we not know that;

that we were
bound in an
unbreakable bond:
Holding us
binding us together,
The moments,
moments of separation
did more;
more to bring us
closer nearer
each other hearts,
souls.
We doeth nothing but;
but thank each
other, for this:
This wonderful,
beautiful,
colourful,
joyful
Life.

MUSINGS

Remember, remember
about you,
your closeness,
your nearness
your kisses,
that's all I do,
Memories of all this
is vivid,
in my mind,
Then I think,
think of the future.
Oh!! it seems;
seems so very
wonderful,
that I can think
of nothing else,
But the time of
togetherness,
nearness,
oneness,
is so very far,
that it seems,
like light years away,
I know, I can do,
do nothing but
wait;
for those moments,
to come in my life,
we were never so:
so deeply in love,
and its so very
beautiful,
so heart warming,
that, that I wisheth,
that it had come

earlier, in my,
in our life:
but fate had deemed
this, Now I can think of
nothing else.
The meeting and
the separation
was heart breaking
wanted these moments,
moments to last,
last forever.
But time is very short,
when joy fills,
your heart
and drags and drags,
when you, are lonely
depressed and sad,
and separated from
a loved one,
wish time could,
pass fast and fly.
But it doesn't,
The only things that
makes time pass
is memories, remembrances,
and thoughts.
But you my dear,
are so far away,
that I can not see you,
but I picture you,
can not touch you,
but feel your touches,
can not kiss you,
but savour your kisses,
can not see you,
but keep your memories.

MEMORIES

Memories,
just memories of you;
you haunt me,
come flooding back,
back to me,
they are so sweet,
pleasing,
that I want nothing,
nothing else to
come to my mind,
I just, just
want to be lost in
them,
lost in them,
lost in that beautiful
labyrinth,
That I don't want;
want to find a
wayout;
They are so nice,
and bright
guiding me to;
to you,
always and forever,
Never was I more;
more lost in
anything else,
but memories cannot,
be realities, I knoweth,
but then reality is,
too for away;
to wait for reality,
seems a lifetime;
Inspite of the knowledge
of the wait,

I wait with these
memories of you;
otherwise the wait,
would kill me,
I talk to you,
laugh with you,
Be close to you,
always;
Imagine, imagine,
that is all;
and do nothing
more,
my imagination
would conjure up
such beautiful
thoughts, never
could I imagine.
All of a sudden everything,
everything is so,
beautiful;
heart warming
pleasurable;
Only your thoughts;
your memories,
do all these
wonderful things
to me,
making one wait,
patiently:
Even this; this
separation becomes
bearable,
Only you; your
memories
brighten me
up.

REALISATION

Drunk, Drunk I am,
by the heady,
drink of love,
I never knew that
it could be so all
consuming.
Enveloping your heart,
your mind,
your soul,
your body,
making you feel,
so complete,
bringing me
close to you,
near you
made you feel
so heady,
so warm
bringing oneness,
All of a sudden,
I want to be lost,
lost in your
love.
I want you to drown;
drown me in your;
your kisses;
I feel so complete,
so sure,
so understanding;
I began comprehending,
everything so nicely,
and so beautifully,
the day was more
bright,

Nights more
warm,
My thoughts, my
dreams,
were filled with;
with only; only,
you,
It dawned on me,
that I was not;
not alone,
any more on this,
road; road of
life,
I had found someone;
someone who
cared for,
loved me,
who wanted to
share her life
with me,
share her thoughts
her dreams,
her LOVE,
her sorrow,
her loneliness.
Who was happy
after sharing
all this and;
and still
love me,
I thinketh, I should
thank you,
But then I should
revere you,
is what cometh to
my mind
or shouldeth, I
respect you.

Is what cometh to
My mind
But I knoweth; but
one thing I love;
Love you.

LOVE

Love,
love was an alien,
word a fantasy,
a dream unfulfilled,
a reality not near
me,
until you; you
came along,
then I understood;
understood what;
what love is;
The dream was no
longer a dream but,
a reality,
It was no longer a
fantasy,
and my thoughts had;
had not to conjure up
any wild things
no running,
no searching,
no more exploring,
all of a sudden, I was;
was in love
and I know it had
come to stay:
stay in my heart,
till; till it stopped
beating; thumping.
Now I understand
all what;
what people had to say:
all that was written on love,
It was, all as people
described it;

The elixir of living,
the essence of everything.
All of a sudden; I was caught up
in this whirling,
twirling world of love.
Lost in it for; for
the rest of my life;
the knowledge;
of knowing that you: you,
also love me,
was what I had been waiting for,
waiting for someone to tell me,
I love you; then
when you said these words;
oh!! What music; music
it was,
A symphony never written;
Its nothing, nothing
more I ever wanted,
Now my dreams,
my thoughts, and fantasies,
do no longer haunt; haunt me;
But the thoughts of you,
you only fill my thoughts
my dreams,
I realize now; now
what love means,
all because of you.

PARTINGS

Why is that,
that we have to part;
part to leave each,
other heart burnt;
to live in this solitude;
far away from each other,
too far away
to even know that
we were close to each other,
so far away that
neither can we
see or touch
each other;
Not even hold each other;
But what can we do but;
but watch helplessly
as we part,
breaking our hearts
leaving each other,
alone;
alone to fend for ourselves.
but the knowledge
of our meeting
in the distant
keeps the boat;
boat of my heart drifting along
till it meets you once again,
How pain full this,
this painting is,
we hath got to know now,
my heart pines for you,
my eyes long
to get a glimpse of you,
my hands miss
the touch of you;

Alas! the dream that,
came true hath;
hath now turned into
a dream once again.
The wait for reality:
begins once more,
when moments of love
will brighten up.
The darkened abysmal
Life of mine once again
How long we hath
To wait:
wait I wish is not very long;
for it would be real long
for this lonesome heart
to bear alone,
I knoweth, the same thing,
the same thoughts
haunt you
But we hath to wait.

MOMENTOUS MOMENTS OF LOVE

How much longer do we;
we wait,
for when we will be close.
But I know you are,
are close to me,
close enough that
that I can touch you;
feel the fragrance you wear,
but when is that I
see you close to me,
close that my dream;
dream turns into reality.
The time is not far off;
so close, but so far,
that the moments;
moments pass so ever slowly.
The watch ticks,
so ever tediously,
Ticks and ticks and they
reach a higher pitch,
splitting this thought,
this dream of you,
inspite of all this,
yet the moment seems
light years away,
like in space,
when time remain suspended
and the astronaut and
the space ship drift,
drift all so slowly,
towards each other.
Reaching their destination
all so very grudgingly.
That one gets exasperated
as to why time does not

fly away;
yet dreams and thoughts
haunt me, surprise me,
please me.
All so refreshing
crystal clear, a memory
vivid and etched on my;
my mind;
when will this memory
become realistic.
Its not very far;
though time may crawl
to come and brighten up my life.
To enliven these,
mundane going ons
something like when
two people in love
who sit and talk
and moments seem to
linger on,
cling close to you;
the joy of being together,
oblivious of what;
what goes on;
what people squabble
behind their backs,
but that moment is,
more than anything
in this world;
Anew dimension
not seen by these
mundane banal,
creatures,
who can not but see
beyond their own noses,
something very high
flown for these creatures,
It becomes difficult
a herculean task,

to teach and tell these
low lying, mortals
of the joy of these moments,
the oneness of these moments,
the closeness these moments,
the purity of these moments,
the expression of these moments,
Oh! what large volumes,
can be written on these moments,
yet they are not enough,
enough to enclose the essence of
these moments;
moments of love.

REALISATION

This is not what one expected,
a love not seen, not heard of.
Oh! What a farce:
what a far cry from, what:
what we had read and
dreamt of:
the ideal love did not exist,
it was only a figment of imagination
of poets, writers and dreamers.
So fluid, clear and always right,
where is that love gone.
Seems it has vanished in this
world of sycophancy this world
of greed, this world of aliens,
this world which longer belonged
to us;
where are we to go from:
from here,
where do we go to find;
find true love,
Do we have to go back,
back into books and poems and
find it there,
its too late now;
Isn't it.
True love has eluded the,
grasp of greasy,
grimey fingers of these
banal human beings,
and belongs now to
an alien world
so very far away:
light years from us,
that we can reach it,
it only in our dreams,

our thoughts our fantasies,
I hope we find it there and
pray that our,
dreams and thoughts and fantasies,
do not hold,
any suspires for us,
which would leave us,
us nowhere to look
for solace,
just wander around,
as we have been doing
for so long now,
when will this quest end,
when will this,
thirst be quenched,
seems millennia away.
A perfect mirage,
How cruel God hath;
hath been on us,
but why do we, curse
its all what we have done
that we get all this.
Leading us to now here.

TOMORROW

Tomorrow comes
and brings along
hope new thoughts,
new ideas,
new dreams.
A new day, a new month,
a new year,
what all can happen,
in a small span;
small span of twenty four hours:
twenty four hours
are even too long
time for any thing.
The world can change in a
few moments,
Decisions can change,
thoughts can change,
lives can change,
But humans remain
unaffected by the
turmoil around them,
plodding on the,
the path of life
with only one aim,
to reach their goal;
their goal in life.
So listless life,
can be
but anyway we;
we have to live this life.
Or we can end this life.
But what abject surrender
this will be,
surrender to mundane

things in life,
we are not so weak,
so weak, to submit
to every pressure;
to finish this beautiful,
short lived life,
live life fully, that's all.

RAIN AND WIND

The wind blows as if,
it were calling me
to the terrace,
as if we were old friends,
but indeed
we have been old friends.
For I have seen,
the various moods,
which are so varied and different.
Sometimes you were so gentle,
that your caress could
put a child to sleep
and other times so
violent that
mountains would shake,
sometimes you
would bring along coolness,
and other times.
You would bring along
heat and dust,
so very contrasting
were your moods.
As your moods changed
so did mine
real true and old friends
we were
long lasting was our friendship
as long as
I was alive.
Even in death we,
would remain friends,
for you would blow
my ashes all over,

Angry to see your
old friend reduced to ashes,
while you could
do nothing to prevent it.

THE GIRL NEXT DOOR

Do not telleth me,
that you careth not.
Then why you always
are these when I
come home.
When I do some work
in the house.
I have watched you
from behind the door.
The look of worry
written over your face,
when you didn't
chance to see me.
The constant enquires,
indirectly showed you,
cared.
The telephone ringeth
and I know it is,
you and no one else
for the phone gets dead,
when I say
Hello!
as if you have been
assured of my well being.
But my heart does
not pine for you,
as I love someone else,
but I respect you,
for the great person
you are,
so very soft,
so very kind hearted,
so very magnanimous
I wish I had
known you earlier,

for then
I would have not
looked else where
for my love.
But indeed a
great person you are.

CONFIDENCE

There you sit,
a damsel so confident
your eyes dancing
sizing up everyone
in a glance.
A look of self assurance
so bright and dazzling,
what you have I mind
know not I,
for I have neither the time
nor the desire to know
for a brief moment in this;
this long life span,
we hath sat together,
you may be wondrous;
why I write
when I see you,
you not knoweth, what
goes in my mind,
but furtive; glances,
you do giveth,
expectin somethin,
which will not happen,
cause we have
different roads to follow.
But we have to walk
along this road for
how much long
only destiny
hath got the answer.
But we wisheth that
we knew destiny
fate.

But alas a dream
it hath remained always.
So evasive,
So distant
that we could not but hold it

HUMANS AS LOSERS

I am talking of the time,
when we were not in love,
when most of the things
were unexplored,
Humans were unaware
of all the things around him,
when humans had not conquered,
water, air, or space or moon,
when all these things
were unexploited, non violated,
when humans were easily
vanquished by natural
calamities,
when humans were not
running; but yet running
against time.
How hard man tried
to run, he was a loser.
But though he was to loser,
man never
gave up stirving,
tirelessly to win over time.
But then there were others
who did run but
they realized that they
would lose, so they walked
never knowing that
now they would
be sure losers.

IF

I and F constitute a word,
word which has
changed a lot of lives,
It is a word that:
one sighs! and says that
one could have done that IF
I would have come first,
If I had studied a bit more,
our love would have lasted,
If I understood you.
If is the word that
fails in the face of destiny.
But without this word.
Human beings
would have no dreams,
no regents,
no sorrow,
what a world it would be,
but then if there
was no if.
Yet one immerses one self
in all the fantasies,
which would have happened,
one begins to
live in a paradise,
which fulfills one's dream completely
and Lo! Everything goes
according to one's thoughts
what a lovely world it
would be if.
It would be better if (Once again)
we never live in
illusions.

REMINENSCIES

Sitting close to the fire place,
watching the glowing ambers,
looking so distant so cold,
but so near and so hot,
chewing on the cud,
I remembered
all the sweet memories
of togetherness and
the bitter
memories of separation
every thought, every remembrance,
was so clear so silent,
I shuddered in cold thought,
That evening was so bright,
filled with life infused with passion.
It was the essence of life,
the chill in the air was cold,
but it generated a sense of
warmth of closeness
an enveloping oneness.
The warmth of your touch,
when we danced and held hands,
The bubbling laughter, full
with life.
Your lovely soft voice, so soothing
and hauntingly pleasant,
It took us not much time to know
that we had fallen in love.
Then everyday, every night
underwent a radical change,
Even I underwent a change,
I went around seeing the world
in a better light, understanding
and communicating with things
around me in a

better sense, more freely
feeling free light and fresh
moving around feeling more sure,
then every story, every dream,
every reality;
has to have an end and
so did our love, have an end.
That day was bright, beautiful
all an illusion an irony,
cause it was that fateful day,
when we knew;
we had to but part,
but we knew that we could not
but keep these memories with us.

UNFINISHED

The beginning was a little of
eye meetings and then holding on.
A more of fleeting glances,
the fluttering of eye lids, telling
something we read,
skipping of a heart or the
heart beating and thumping
a trifle more faster,
Our first meetings were always,
so short, precise and courteous.
Then there meeting became
longer and
all the pieces of the puzzle of;
of love fell into place.
I told you how I felt towards
you, and then you;
you told me that you felt
the same way for me; then
I knew, I had to build
my love and world around you.
You were just the one
I imagined, liking develop a into love.

KISSES

The joy of the first kiss,
the joy of holding
and feeling you in my arms.
Finding security
in our new found love,
the sharing of
thoughts and secrets,
our love begin to bloom,
its fragrance,
so soothing
and so heady.
The light of our love
was bright and dazzling,
like a light house for me,
guiding me through,
the dark murky
frightful sea of life.
Our love was
a guiding light
guiding us
to the ultimate goal
of self realization.
But yet we were
far away from that goal.
As we were
bothered about
more banal
and little things
like worldly affairs,
something went wrong
something, somewhere:
something went wrong
in our chemistry
and a violent reaction
went through,

we were not ready,
I thought so,
to leave everything
for our love, our love
fell through,
Like we had tread
through a paper floor,
we were hurt
and tried not to think so,
but it was true,
yet we tried
to cling on
to the drifting love,
but like a meting glacier
chasms and voids
developed which:
grew, we could do nothing,
but watched helplessly
as we drifted apart,
unable to do anything.

TOGETHERNESS

Sitting together,
when we were alone,
whispering sweet nothing
in each other ears.
Speaking through our eyes
conveying so many unsaid words,
so many expressions,
speaking to each other,
through touching each other,
expressing warmth, openess,
speaking to each other,
litreally, conveyed nothing
as much as when we spoke
through feelings, through
emotions unexpressed.
Yet we spoke when we
were away from each
other.
When we could not see, touch
or feel each other,
yet we were close to each
other, so near, so far,
yet it is true, we
were in love with each
other,
The letters of love, we
wrote are treasures not
matched by any worldly treasures
moments with, you are
moments vivid still
moments which come in a lifetime,
something like a natural spectacle,
which was and is always a
pleasure to see and
remember.

FIRSTS

Sometimes I think,
the very first day,
the very first moments,
was so good: so exhilarating
that it should were lasted forever.
But time is an image shatterer,
those lovely brown eyes,
that toothy smile,
your way of looking at me,
I was floored,
never was I impressed by someone,
so diminutive, but so great.
The way you conducted your self
was a treat to watch.
I don't know what went on,
but we were caught up
is a whirlwind of love.
A whirlpool of joy,
so abysmal unending,
love was so new
and yet so old.
Old as I knew about it
and new
cause I experienced it
so closely
for the first and last time.
Time was non existent,
having no meaning
for me as long as
was with you,
yesterday I remembered all the words,
we exchanged,
all we thought of,
the way we looked at each other.
But time and distance were there.

53

Life is so lovely,
with all its ups and down,
its niceties, its absurdities,
its joy,
its sorrow,
its wrath,
its benevolance,
its love,
its hatred
many people have
plodded by,
but no one
has yet been
able to describe it aptly.
Some have taken
life very casually,
others have tried
to comprehend it,
spending a life time
yet they

hath not understood,
enjoy life
as it comes
never be disgusted
with what happens,
cause something
happen which
are out of one's control.
Everything was going smooth,
then it went like rough seas,
the waves of fate.
Were too strong,
I was going along happily,
then they hit me

and I was reeling
under the effect of it
though I tried
to understand life my self;
in the short life span,
I hath
not understood,
but life's only answer,
answer to all queries
and its only description
is death

RUDE AWAKENINGS

When this happened,
where were you,
were you for away;
no, you were close
as possible to my heart.
But later I realized
that it was just an illusion,
but what a lovely illusion,
I just hope it could carry on.
But it was so short lived,
no memory of it ever remained.
Remained,
were just a few,
precious moments,
moments so precious,
that, they were
more than the costliest things in the world,
you had more important things to do,
but you cared for me,
you never could muster up
enough wits to tell me so.
Neither could I
now its been a long time
and much dust hath
fallen over the pages of time,
No need to dust it off
and start a new end,
from where everything stopped.
It would be better if,
you started, you may have started,
a new chapter all together
it seems so nice
to have nothing to do with you,
everyday is new
and everything so fresh,

I never knew
the sun was so yellow,
the dew could look
like marvelous diamonds,
the flowers had
so fresh colors,
that they could dazzle you
and the world was
so nice to live in without you.

JOY FEELINGS

Joy was a feeling,
I always experienced
when I was with you.
It came when I touched you,
held your soft
fragrant hands
when I kissed you smack
on your lips or
when I held your
fragile frame in my arms.
The feeling experienced
when we, were
together has always
lingered in that
obscure corner of my mind.
The atmosphere was
electrifying when we
sat together and
when you talked
it seemed, as if
something was really
sending waves of
ecstasy through every cell
of my being did our souls meet,
I really don't know
but our hearts,
they were welded in an unbreakable bond.
Those lovely brown eyes
always bright and
gay as if they knew no sorrow.
I was so enamoured by you,
that I saw no one but you.
You had that grace
around you which made you different,
was it love or understanding

that held us together,
yes it was love that brought us
together and understanding that held us together.
My heart missed a beat
and begin to flutter,
when I first asked you whether you loved me,
Then it stopped for sometime,
I when you said, yes
the electric spark that was there
became a great thunder clap,
I became oblivious of all other things around me.
I saw everything in you,
I just could not help my self,
but falling in love with you,
but what about the future,
I thought this utopian world of
mine would shatter.
The thought made future
look dark and but I was wrong,
when met you again,
the sorrow in your voice told me,
you missed me and when I consoled you,
the joy, bubbling laughter, told me
that I would not be alone; on this long drudge,
called life.

PARTING PANGS

The calamity was coming,
I knew but,
But I could do nothing,
I knew, I would,
I would, would be
left alone to
fend for myself.
No one to share
my joys and sorrow with,
my agonies: my ecstasies.
No one to lend
a shoulder to,
when I wanted to cry.
No one to look upto,
No one to idolize,
the void was being felt,
the unending pain,
the abysmal suffering
was there,
but there was no,
way out, no diagnosis,
no tablets to
be given for this pain,
but I knew, I could not think,
it was not there,
the reality could not be denied,
could not be said
that it was wrong.

MOTHER

To tell you,
tell you that
I love you,
Is what has been my only desire,
I have seen, seen
you for so long,
Every since I grew up,
The joy of being, being
with you,
was boundless,
the thrill of holding you,
was all that I wanted to do,
I only wanted
to tell you: I love you,
For so many years,
you were my everything,
my inspiration,
my will to do something;
my pillar of strength,
A light house,
lighting my times of darkness.
The more: more I stayed;
stayed away from you,
the more I loved you,
The pangs of separation
told me that
I wanted to be with you,
everything I have done,
Has been due to your,
your help,
your understanding
your love,
thank you,
Mother, thank you,
you are all that I revere.

WINDS OF REMEMBBRANCE

The wind blew,
bringing along a whiff,
of freshness
a sense of nothingness
calming the turmoil within me,
cooling the storm came
the clouds, cooling the air around,
making things dark,
but dark they did not bring.
They brought along the first showers.
The smell wet mud came
as the refreshing whiff.
Everything looked damp
but not so damp.
The sunshine thence
seemed so bright.
Everything looked so new,
and bright.
The thrill of walking
walking in
small puddles.
Wetting my drowsy feet,
A cool wind blew
making the walk
in the fields so fresh
and the chill in the air.
Chilled me, making me,
collect my, woolen closer
and I tried to
be more warm,
The hot cup of tea,
next to the fire place
brought the warmth
back in me, in my bones.
Reminding me of
my lovely days past.

NIGHT

The night was going,
taking away,
the stars,
the darkness,
the loneliness,
The noises of the jungle,
the crickets,
the hoot of the owls,
call of the jackals,
Instilling in one,
the sense of fear,
loneliness,
though the doors,
windows of my room
were closed,
the stars, started diminishing
and the sky was turning
red with a splash of orange.
As if a painter had: had
spilled his colours on a canvas,
Yes, it was colours: colours
used by someone
to paint this world in
its various colours.
The sun was coming
the bird started chirping,
looking busy.
The orange turned crimson
and then yellow.
The air was fresh.
Bringing a cool freshness.
Tingling, raising: raising
the goose bumps.
The walk in the garden,
moving along the rows: rows

of daffodils, pansies.
Splashes of colours.
But this tranquility; tranquility
would end soon.
When everyone got up
and factories started; started
spewing clouds of smoke,
into the skies.
The noises of the
cars, trains, train's horns.
Deafening
making this world a
madhouse
Where I had to live, walk,
breathe till the end,
but then I knew; knew
the night was there
once again bringing tranquility,
serenity.
The breeze would; would
take me to the terrace
and then to the fire—place,
where I would sit warming
my self.

ROAD

Yet we knew,
not where we were going,
where this road,
would lead us,
where this drudge of life
would take one.
But we went on
enthusiastically taking every turn,
every bend, every blind alley
in our stride.
The zest to live,
the zest to know,
kept the sprits high;
high as the sun in the sky,
walking running,
we went on,
relentless of what came ahead.
Moving along,
expecting, the thing,
we wanted to know at every turn,
every step,
But everything;
everything seemed
elusive
out of the grasp of humans.
Then we walked trudging along,
now the road of life
seemed long and tiring
plodding on and on.
With nothing so bright,
so beautiful,
everything so dull,
But we knew,

we had to carry on,
To reach the end of the road,
to reach the eternal truth
death.

FACADE

The outer out look
was a farce,
A face be had to put up.
To tell the world
that he was one of then,
one of the multitude.
He wanted identify himself with;
with the people.
He did not have any courage
any individuality to come up,
to revolt and tell the world
that he was different.
He was an individual a person
with thought
with feeling,
with emotions,
with the need for shelter.
The need of love.
The desire to live,
they way he wanted,
to do something.
But the fear,
the fear of rejection of his peer,
his society,
compelled him to do
as they did
never questioning
as to why
certain things are done
in a particular way.
So he drew the shell closer,
cutting out everything,
that would make him change his,

thoughts, his life.
Make him an alien
in his near and dears.
So he kept plodding on,
as the others did.

FUSION OF EYES

The meeting of eyes,
the eyes speaking,
telling everything,
we wanted to know,
but why,
why is that,
we can't talk,
like normal people.
The eyes told, everything,
we didn't have to talk literally.
Fleeting glances,
showed you cared.
The eyes shone,
when you were happy and at times,
expressionless.
So dark unfriendly,
I didn't know, why.
But I never wanted to talk to you.
I only wanted our eyes to talk.

DAY—DREAMERS

What a lovely day dream
Dream it was picturesque,
lovely heart warming,
Alas! It had to finish
like a bubble
formed so quickly and destroyed
equally fast.
Everything looked like
something new,
something good.
The experience of drinking
the sparkling, crystal clear
cold water of the streams,
so blue, so refreshing:
An oasis in the hot desert,
endless were the bounties
of nature: never finishing,
but man:
never kept his hands to himself.
Using destroying,
making everything scarce.
Doing everything for his welfare;
never caring,
never looking into the
beings around him.
Never seeing, the marvelous,
colours of flower; the magnificence of rivers,
mountains, gorges, the thunder,
the clouds, of the trees,
the sunset,
the brilliance of the sun,
the moon, the butterflies,
the insects, the birds the grace of a lion,
a tiger or a deer,
the noises of the crickets,

the bubbling streams',
the clapping of thunder,
the chirping of birds,
the rustle of leaves,
the sound of wind,
the plops of raindrops,
never seeing,
the perfect colours,
the brilliant yellow of the sun,
the blueness of the sky,
The whiteness of the snow,
The green of the grass,
The trees,
The grey of the clouds
The colours of the;
Rainbow,
The silence of dawn,
The darkness of the night,
The light of the morning,
The serenity of the evening,
The noises of the woods,
The stillness of the ocean,
But not so still and calm,
But not so still and calm,
Serene and beautiful on the surface.
Turbulent and hideous below,
Enveloping within it a,
a multitude of life,
a supporter and a destroyer,
what a fortune it was,
it was to live,
close to nature, knowing
that I had acquired,
the greatest wealth in,
the world,
I needed nothing more.

FLEDGING STEPS

Dawn came and went,
Sunset came and brought,
along,
A sense of serenity,
calmness,
peacefulness,
looking at the sun drop,
beginning to set,
looking at the clouds
in various forms;
Lined by the sun,
Some sunlight filtering through them,
Like a mystic light,
The sun underwent a change,
It became cool,
Subdued tired,
After a day's journey,
Across the expanse of the sky;
Looking so small, yet;
Yet so expansive, vast,
Unending; or does it have any boundary,
The way it changed
Shape,
From a perfect circle,
To a perfect oval,
Looking at this, with,
Darkness setting in,
So very slowly as if,
It had been preplanned
a plot hatched;
hatched by,
forces unknown to us
to envelope,
the world in an,
inkling darkness,

DANGER ROADS

As I ran along,
My muscles taut,
 With my comrades falling,
 The desire to do,
The impossible,
Became an obsession,
 A duty I had to complete.
 Then I turned round,
The corner,
I knew not, what;
 Was lurking round,
The corner,
Love life, joy or
Sorrow,
Or the ultimate adventure
Death.

SIMILAR DISLIKE

Life and nature,
 Are two similar, dislike,
Things,
 They have no friends,
No enemies,
 They test everyone,
Big or small,
 They treat every body,
Alike.
 They ruin and eliminate,
All great or small,
 Powerful or weak.

WAITING

Waiting; in the biggest curse,
Waiting for a reply of a letter,
Waiting for the telephone to ring,
Waiting for someone,
Waiting for time to pass,
Waiting for a Bus,
Waiting for a Train,
Waiting for a flight,
Waiting for death,
Waiting just waiting,
for everything,
But time never waits,
Death never waits,
They just come and go,
Taking away a lot
of things and
leave behind only
memories
Faint recollections of,
Of the past.

COPY CAT

Back is the warrior,
Home from the battle field,
With a million tear,
Tear drops in his eyes,
Which cannot wash away the blood,
Blood stained memories of his dead comrades;
Memories, which will haunt him;
all throughout;
Thoughts which will take;
Take him back with his comrades;
Now a sure memory.

INDEBTED

Indebted to you I am: Indebted indeed:
for good you see in me:
indebted to you I am: indebted indeed:
for beautiful you see in me:
Indebted to you I am: indebted indeed:
for caring you see in me
Indebted to you I am: indebted indeed:
for friendship you see in me:
Indebted to you I am: indebted indeed:
for sharing you see in me:
Indebted to you I am: indebted indeed:
for guidance you see in me:
Indebted to you I am: indebted indeed:
for confidence you see in me:
Indebted to you I am: indebted indeed:
for choosing me your friend:
Indebted to you I am: indebted indeed
Indebted to you I am: indebted indeed:
for making me try to be good:
Indebted to you I am: indebted indeed:
for making me try to be caring:
Indebted to you I am: indebted indeed:
for making me try to be beautiful:
Indebted to you I am: indebted indeed:
for making me try to be a guide:
Indebted to you I am: indebted indeed:
for making me try to be a confidant:
Indebted to you I am: indebted indeed:
for making me try to live upto your expectations:
Indebted to you I am: Indebted Indeed:

JOURNIES

Journies we take every day
Some cheer ful
Some happy
Some sunny
Some rainy
Some slushy
Some sandy
Some cloudy
Some thundery
Some gusty
Some still
Some running
Some sad
Some long
Some tumultuous
Some thrilling
Some heart wrenching
Some aimless
Some heart warming
Some spiteful
Some short
Some sorrowful
Some painful
Some gutwrenching
Some snatched away from
Some clung to
Some loving
Some holding hands
Some alone
Some enemy laden
Some friendly
Some lovingly
Some warm and comfortable
Some soulmatedly
Journies: journies make life